The Land We Dreamed

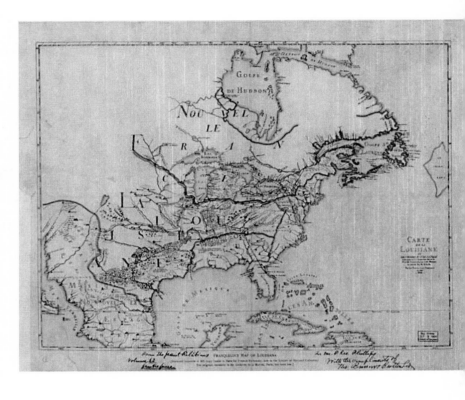

The Land
We Dreamed

Poems

Joe Survant

UNIVERSITY PRESS OF KENTUCKY

Scholarly publisher for the Commonwealth,
serving Bellarmine University, Berea College, Centre
College of Kentucky, Eastern Kentucky University,
The Filson Historical Society, Georgetown College,
Kentucky Historical Society, Kentucky State University,
Morehead State University, Murray State University,
Northern Kentucky University, Transylvania University,
University of Kentucky, University of Louisville,
and Western Kentucky University.
All rights reserved.

Editorial and Sales Offices: The University Press of Kentucky
663 South Limestone Street, Lexington, Kentucky 40508-4008
www.kentuckypress.com

Frontispiece: Franquelin's map of Louisiana, 1684. This is one of the
earliest known maps of North America. (Courtesy of the Geography and
Map Division, Library of Congress)

Cataloging-in-Publication Data is available from the Library of Congress.

ISBN 978-0-8131-4458-0 (pbk. : alk. paper)
ISBN 978-0-8131-4461-0 (pdf)
ISBN 978-0-8131-4460-3 (epub)

This book is printed on acid-free paper meeting
the requirements of the American National Standard
for Permanence in Paper for Printed Library Materials.

Manufactured in the United States of America.

 Member of the Association of
American University Presses

for Jeannie,
too soon gone

We . . . traveled about thirty miles through thick cane and reed, and as the cane ceased . . . a new sky and strange earth seemed to be presented to our view. So rich a soil we had never seen before; covered with clover in full bloom. . . . We felt ourselves as passengers through a wilderness just arrived at the fields of Elysium, or at the garden where was no forbidden fruit.
—Felix Walker, with Daniel Boone, March 10, 1775

Stand at Cumberland Gap and watch the procession of civilization, marching single file—the buffalo following the trail to the salt springs, the Indian, the fur trader and hunter, the cattle-raiser, the pioneer farmer—and the frontier has passed by.
—Frederick Jackson Turner, 1893

Contents

IV. Long Hunter

V. Voices from the Great Migration

VI. A Codicil

Preface

The Land We Dreamed is the last book of my trilogy about rural Kentucky. It attempts to satisfy a long and deeply held curiosity about the early experiences of people in Kentucky, beginning with the first Ice Age hunters who wandered south of the glaciers into what must have seemed a paradise and stretching to the pioneers at the edge of civilization in the late eighteenth century.

As a boy hunting squirrels in the extensive woods of Panther Creek Bottoms near Owensboro, Kentucky, I wondered what it was like there two hundred years ago, when there were panthers among giant, untimbered trees. Older, sitting around campfires in bigger woods, my curiosity reached back, past the record of the first colonial hunters wandering in from east of the mountains, to the very first people to enter Kentucky. Who were they? What did they see? What was it "like"?

This book is an attempt to scratch the itch of that curiosity, to say what it was like, but it is not a history. It is a small net of imagination cast into history, both the known and the unknown, seeking to catch the little fish of experience that dart through history's larger one. In order to do this, I have tried to create as realistic a context as possible. There are a few well-known historical figures here: Dr. Thomas Walker, Mary Draper Ingles, and the hunters and trappers Daniel Boone, James Drake and Casper Mansker. Lesser-known are the Shawnee chiefs, Nimwha and Lawaughqua, the Seneca, Kyashuta, and James and Jane Trimble. I throw in my own

obscure pioneer ancestors for good measure. The other characters are fictional, a product of reading and the imagination. The two French Jesuits, for whom I appropriated the label "coureurs des bois" from its more historical use to describe French hunters and trappers, owe their existence to the late historian Lowell Harrison who, one morning over a cup of coffee at Western Kentucky University, fired my imagination by suggesting that the first Europeans in Kentucky might have been Jesuits wandering down from French territory around the Great Lakes.

I

The First Hunters

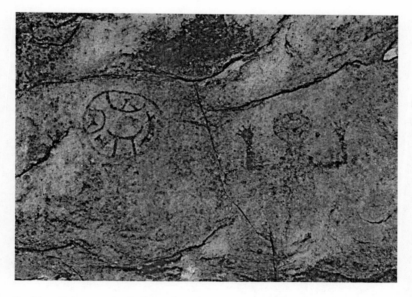

Prehistoric hunter. Asphalt Rock Pictograph, Edmonson County, Kentucky.
(Courtesy of Jackson Glisson, Kentucky up Close! Photography)

The First Hunters

Where they lived
it was cold.
There were storms.
All was frozen.
Even the sea
had a mighty
desire to freeze.
They dreamed
of milder lands
full of great elk and
herds of the giant buffalo.
Generations went east,
they went south
over the snowy plain,
over the frozen sea,
over the hard
slippery water.

Of these people
the freest were
the hunters,
the purest were
the hunters.
They did not
build houses together.
They followed the animals.
They found the
mighty path made
by elk larger

than four deer.
They found the
path beaten down
by great buffalo
whose horns grew
from their mouths,
long curving moons.

The hunters followed
this road south,
stopping at salt
places where all
the animals came
and the hunting
was always good.
They followed the
trail and hunted
the salt springs
until they came
to a beautiful river.
Crossing the river
they found a place
with great trees
shading rolling
hills of grass and
tall stands of cane.

The animals had
never been hunted.
The animals were many.

Buffalo traveled
in large herds.
It was easy
to kill them
for meat and robes.
Deer started
but did not run far.
Bears grumbled
and stood up
like men to stare.
The hunting was good.
The living was good.
The sun always shone.
The deer and buffalo
loved the clacking cane.

The people were happy.
The children's bellies
were always full.
The women smiled.
The hunters talked
among themselves.
They smoked and
talked some more.
They poked at the
fire with sticks.
Let us stop here,
they said. *Let us
live here, near
the animals. This*

is the land
we dreamed.
This is the land
Manito made for us.

The Turtle Clan

Turtle.
Father.
Deep runner in flood.
Blind mole
in Oyo's sucking mud.
We see you sunning
on warm banks.

Diver,
we cannot follow you.
Mossback,
we cannot see you.

Swimmer in our blood,
you rise from ancient mud.
Turtle.
Father.

II

Coureurs des Bois
1638

*The French had, since the year 1524, often visited the coast of
America. . . . Finally, at the beginning of the last century [the
17th], Samuel Champlain . . . entered the region of the interior.
Already was the undertaking progressing very favorably, when
Henry IV, more solicitous for religion than for commerce,
resolved, in the year 1608, to introduce Christian rites into this
part of the New World, and asked the members of the Society to
undertake this Apostolic enterprise.*
 —Fr. Joseph Jouvency, *Jesuit Relations*

*The land which we have gone round is very good. If the Lord be
favorable, he will bring us into it. . . . Fear ye not the people of
this land . . . the Lord is with us.*
 —Numbers 14:7

Noel Chabanel

Dieppe, 1638

I.

I saw her first
at sixteen dipping
long black braids

in the horses' tank,
the other girls skipping
around her in a dance.

I kissed her later, and
she kissed me. When she
was seventeen, we married.

At nineteen, she
coughed up little spots
of blood, then torrents.

Fevers and night sweats
began, and a strange
flushing of her cheeks.

At twenty she was gone,
slipping through my hands
and out of nature.

In my grief's rage
I rushed into
the hogs' closed pen

with a sharpened sickle,
hacking furiously at
dumb huddled animals

who had no part
in my grief until
I finally slipped

in the bloody gore while
the hogs knocked against
the rails with an awful squealing.

II.

Louys put his
big butcher's hands
hard upon me,

and I lay subdued
on the barn's dirt floor
for a day or more,

bound against my
madness and for my
neighbors' fear and anger.

Father Jerome came
and spoke quietly, then
slowly untied me.

He gave me wine and
bread and watched me
eat and drink. He

saw my torn clothes,
my bruised and beaten body
where Louys restrained me,

saw my slowly fading
frenzy. He watched for
a long while, then said,

*Noel, come with me
to help as I rescue
souls in the Huron Missions.*

I looked around and
everywhere I saw
the awful shape of her

absence in the gloomy
air and printed on my
eyes. I saw too the

dark patina of sorrow
that would be a lasting
mark of my madness.

So, I went with him
and sailed from Honfleur
across a wide and empty sea.

Father Jerome Clermont

1638

Though we sailed in May,
it was winter on the northern sea,
and our cabin so low we could not
sit or stand. Rain seeped

through and wet my frozen feet.
We ate salt food and suffered
terrible thirst. Always
our ship was tossed in a

gray and angry sea. I
remembered the luxury of
thinking of death in my cell
at Dieppe, the crucifix before me

on my wall, the sea roaring
safely outside, but on the boat
we floated in a presence
that seemed the absence of God.

One morning the ocean calmed
and we passed two ice islands
larger than our ship, shining
in the sun like crystal cathedrals.

The weather softened and we sailed
into the great St. Lawrence, wider than a sea,
and entered the boreal land
where my martyrdom would likely be.

Noel

The good Father suffered
terribly. I feared
he'd lose his feet,

and the sea's blankness
and the wind's mindless howl
pushed him toward despair,

but I thrived in the storms
and cold. The wind's noise
was a relief to me, and the sound

of waves, and the unspeakable depths
below us where time
and memory are drowned.

Among the Illinois

I. Fr. Jerome

When I saw them wearing cloth
I judged they were our friends,
Illinois, *the men,* as if the
other tribes were something else.

Their captain greeted us, naked at
his door. He held his hands up
to the sun as if to pray
but the rays passed through his

fingers and lit up the paint
he wore upon his face, black
across his eyes and cheeks.
How the sun shines, Frenchmen,

when you visit the Illinois.
Inside we sat and smoked,
I at ease while Noel was afraid.
Many had come to see us,

Frenchmen were still a novelty.
They lay upon the grass and wondered
at our hair and skin, and how our robes
were made. When I spoke

they grew quiet and listened.
The God who made you has

sent me. The great Captain of the
French will conquer the Hiroquois

who scalp and burn your warriors
and take your women and children.
Ka-kag-a-su answered, *I thank*
you Black Gown. Never has our river

been so calm or clear of rocks
which your canoe has swept
away in its passing. Never has
our corn grown so tall. Here is

my slave whom I give to show
my heart. Then he came and sat
beside me. I asked the way
to the Hiroquois tribes, but he

begged me not to go. *You have*
no guns. Arm yourselves as we
are armed, for they are a sly
and murderous people. Many men

have died in chains at their burning stakes,
their flesh cut and eaten before them.
Do not go among them. I replied
I was happy to die for the God who'd made us.

The people murmured and thought us fools.
Noel looked as if he agreed. But I was not afraid.

The Virgin had appeared to me in a dream
of blue tobacco haze, *It is not yet your time.*

II. Noel

The next day was a feasting
day, and in our honor.
First they passed a great

wooden platter of their good
corn sagamite, steaming
with bear fat. Their shaman fed

the Father the first bite
as though he were a child,
then me and the others.

The second platter held
three large fish
with bones removed. He

blew to cool them,
then fed us again.
The third course

was a large dog,
freshly killed and roasted.
We said we could not

eat the meat of dogs
so he brought fatty
pieces of wild cattle.

Again we were first
to eat. I felt
like a pig before slaughter.

After the feast he
led us through the town
of over three hundred cabins

and called the people out
to see us. Everywhere they
pressed gifts upon us,

belts and garters made
of hair of deer and bears
dyed red, black, yellow.

The Father gave them
banners of Chinese taffeta
with images of the Virgin.

I kept only the calumet
Ka-kag-a-su gave me—
and a pouch of good tobacco.

Fr. Jerome

He thinks he hides his grief
within, but I see it perched
on his shoulders like a sailor's
monkey, whispering in his ear.

He thinks I don't see
the fine razor that divides
his heart and head. He thinks
I don't see his struggle

with Christ's promise.
I see his Jacob's match
and watch when he sits
alone, fingering his rosary of grief.

Night falls like a cage
around us. I reach
out to him, but he looks
inward, full of a heatless rage.

Noel, Cogito

I admire Father Jerome
and know the strength
of his faith. I've little

of my own. We're
together gone the length
of Lac des Illinois.

Now I'm to Quebec
while he goes alone
to winter with the Hiroquois.

He'll learn their words
and we'll meet in spring
to seek the southern tribes.

I don't believe
I'll see the Virgin there.
Nothing but the noise

of my mind seems
certain until its clamor
rises and oppresses me,

doubt flows even there.
I must practice a
discipline of emptiness—

unlike the Father's full
of solid faith and solace—
one that can wrestle

the world to its knees,
and when it turns up
empty, let go if I please.

Leaving France I vowed
to seek no knowledge
than what's inside me,

or can be read in nature,
however brutal the book.
It may be that

I'll die a heretic
as the Father warns,
but sometimes there seems

something in the wind
when nature is around me.
Perhaps Spirit as the savages think—

or just a lower part
of seeing, like a dog musing
on the mind of Descartes.

Fr. Jerome Hears of the Shawnee

The Hiroquois barely tolerate me
and have driven away all Algonkins—
Illinois, Chippeway, Miami, and
people they call *Shawunogi,* southerners.

I ask why fight tribes so far away.
They are our enemies, they say,
Ontoagannha, people who cannot speak,
not Hiroquois, or Mohawk, but others.

Shawunogi slaves from recent raids tell
of their home on a beautiful river, Oyo,
where it's always spring, summer, or fall
and the soil's so fertile their corn's like trees

with ears a foot long and grains
as big as muscatels. They miss their home
and hate the winters here, but fear
the burning stakes and do not flee.

The Hiroquois won't kill me now,
though they've taken off an ear,
but their cabins and fires are closed to me,
and I need a place to winter.

Winter among the Mystassins

Fr. Jerome

This cabin of poles and birch bark fills
with the smoke of a smoldering fire.
My clothes and hair reek with it.
My eyes burn and weep with it,

by morning swollen shut so tight
I stumble out into the cold
rubbing off a thin crust of dried
rheum and collapse in a coughing fit.

Cold is everywhere, blowing through
the bark walls, seeping from the ground
through my fir-branch bed. My head
feels tamped with woolen lint.

I eat from a dish cleaned with greasy
hides, or licked by dogs. I wipe my hands
on their fur as they press forward.
They growl as if they mean to do me

harm, but do not bite. This morning
I awoke with five standing around me.
The Mystassins ignore me, but their dogs
must think me a weak and dying meal.

Ka-wa-ska's sick son sleeps
near me and the rotten smell of his scrofula

turns my stomach. We eat from the same
bowl and pick deer hair from our meat.

Daily despite the cold I shake out
my cassock and stockings to throw off
the vermin that infest me. Never have I
seen savages so dirty. I fear my death

among them, yet must not complain
confronted with the suffering of one before
me—the slow death and torment of
Father Jorges in the camp of the Hiroquois.

Here with the Mystassins, I endure only
what they endure, a hard life in a cold
hard place. I accept my fate among
them, and to my faith bear witness.

God grant that I may live out
this winter and go on to the southern
tribes on La Belle Riviere before I die,
a worthless servant of the Missions.

Noel

1639

He returned in April
when the ice was melting,
so weak and sick

I hardly knew him,
his eyes black and sunken
like the holes of burned

out stumps, a terrible
wound on the side of his head
where the Hiroquois had cut him.

Though I warned that
he would die and never
reach the southern tribes

he would not wait.
So we took our bark
canoe, and went upon the river.

By the second week
the bloody flux was fully
on him. We stopped

for rest and I made
a hut of limbs of fir
and he lay in it.

Even water passed
quickly through him,
and he grew weaker.

He said he'd die
tomorrow, but I
didn't yet believe it

and vainly tried to clean
him. At the end he
mumbled and stared hard

at something in the trees
then died so quietly, I
thought that he was sleeping.

Memento Mei

Fr. Jerome

Maria, mater gratiae, mater Dei,
memento mei, I pray
against this bloody flux
that eats away at me.

Yet, I have sought this death
in the Huron Missions where
God has sent me, but regret
I do not die a witness

for the southern tribes. I
cannot see the trees around me,
but still see clearly the Illinois
gathered around for their first mass,

and smell their heavy buffalo
robes, the air full of smoke
from their cooking fires. The Chinese
taffeta of the Virgin was like

a surprise when a wind
raised the silk in air and
made the Virgin float above us.

But now the strange beasts
we saw painted on a rock

wall of the river come
to have a go at me.

Mater Dei, memento mei.
One plunges his scaly tale
into my bowels and I foul myself,
a stinking red corruption

in this little hut Noel has made
us. Then She motions them away
and pulls aside the darkness with
Her white hand, and shows the

tunnel of my agony, as I have
chosen. I strain to better see
the terms of my martyrdom.
Memento mei, memento mei.

Noel, Seul

I.

I buried him above
the river, a blanket
over his face and

rang the little hand
bell of his chapel.
I piled rocks

on his grave to keep
the animals out, then
waited, but around me the

wilderness was silent
and I could not move.
A breeze came

up and shook
the early sugar trees
to a quick shining shimmer.

I had no choice.
I loosed the canoe, and
went alone upon the river.

II.

Under an infinite
canopy of leaves
I enter a mystery

unlike the blank forests
of the north. Stopping
to rest, I find

small wild strawberries
shining like sacred hearts
in their green viny nests,

but tasting not so sweet
as the berries of Dieppe.
I see again their stain upon

her lips and taste the juice
upon my own. I thought
this wild world would divide

me from myself, but
look and find my grief
hiding in these leaves.

I hear it in the
woodpecker's furious
beating in the trees.

I cannot see my feet.
I turn and stumble
on the mole-molested ground.

La Belle Riviere

I.

On the tenth day
having made my way
down the Ouabachi, I

reached its mouth and entered
a beautiful river the Hiroquois
call Oyo. Ducks and teal

flocked feeding upon wild
oats waving gently
in the water. Bustards and swans

without wings swam noisily
together. Wild cattle lifted
heavy heads from drinking.

Water ran from their beards
as they watched and snorted.
I wished Father Jerome here

to see this little piece
of the Garden shining so
peacefully before my passing.

Once a tremendous fish
struck my boat like a log
and threatened to break it.

I saw also on
the water a monster with
a tiger's head, whiskers

and nose like a wildcat,
sharp ears erect
on its wide gray head.

Around each bend
floating flocks of geese
scattered from my canoe,

but I saw no signs
of men, the Shawunogi
who live along the river.

If this is the way to
the heart of this wild world
I vainly hope the people

here are like their river
which flows so leisurely
before me. I'm glad

to leave the hard North
where Hiroquois are quick to chop
and burn us for their pleasure.

II.

Like maskers at
carnival they came,
out of dark trees

and the leafiest of shade.
Some had painted black
masks that ran from

ear-to-ear around
their eyes, their faces
a fierce and brilliant red,

others had noses blue
or yellow, faces black
halfway up their brows,

halfway down their chins
looking as if they could
be peeled off at a whim,

their skin the copper
color of our French beggars
roasted by the sun.

One wore a bearskin
despite the heat, like
pictures painted of John

hesitantly baptizing Jesus
down in the muddy Jordan.
Others wore only hides

hanging from their waists
by cords twisted from dried
intestines, the women

modest in dresses of skins
hanging to their knees.
All had long black

hair tied back in
shining greasy strands.
I sat still as

they approached,
then slowly stood and
walked toward them

holding out my empty
hands, and, thus, in silent
hesitation, everything began.

What He Found

not wilderness or empty space
Eskippakithicki blue lick
last Shawnee place

3000 acres shaped
by buffalo and people
on the Great Warrior's Trace

cabins palisaded near
the cleanly flowing creek
fields of squash and corn

Ottawa and Miami
Illinois and Lenape
Piqua and Shawnee

coming and going
from raids or hunts
squatting to smoke

women working fields
stoking cooking fires
skinning gutting game

smell of smoke
carcasses scalps
hides drying by fires

licks bringing buffalo
shouldering shoving
over salty ground

buffalo heavy bodies
threshing lush fields
of grass shoulder-high

wide-racked elk
clattering stomping
in hollow cane

bears bloated bullies
stained with blackberries
standing snorting

deer traveling narrow
secret lanes in sumac
cedar and sassafras

pigeons heavy at roost
mourning at daylight
and heat of noon

turkeys barnyard geese
dissolving in woods
along the creek

fish in schools
perfect selves
in warm shallow pools

catfish yellow and horned
hiding in hinges
layered limestone shelves

herons long blue
needles searching the
stream's floating trash

elm's fine architecture
honeysuckle bound locust
restless lakes of cane

white oak black walnut
silver beech red maple
black cherry blue ash

Eskippakithicki, a pause,
a brief parenthesis
between the hill and creek

III

Ken-ta-tha

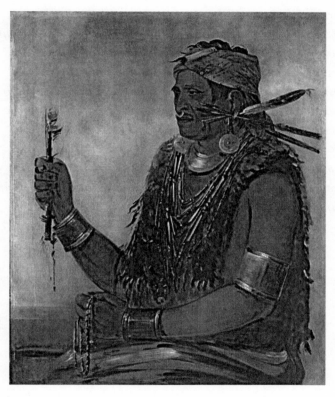

Tenskwatawa, "The Prophet." Portrait by George Catlin.

Brothers, you see this vast country before us, which the Great Spirit gave to our fathers and us; you see the buffalo and deer that now are our support. Brothers, you see those little ones, our wives and children, who are looking to us for food and raiment; and you now see the foe before you, that they have grown insolent and bold; that all our ancient customs are disregarded; the treaties made by our fathers and us are broken, and all of us insulted; our council fires disregarded, and all the ancient customs of our fathers; our brothers murdered before our eyes, and their spirits cry to us for revenge. Brothers, these people from the unknown world will cut down our groves, spoil our hunting and planting grounds, and drive us and our children from the graves of our fathers, and our council fires, and enslave our women and children.

—Chief Metacomet, Massachusetts, 1674

On the Ohio

Wabete, 1756

I am in the canoe
with my father again,
after Monongahela
where Braddock died,
he who said
No savage should
inherit the land.
I do not yet know
my father will die
at Brushy Run where
blood ran white and red.

He motions me ashore
to tie the canoe.
The bank is steep,
a smooth gray stone.
I climb until
he is lost
in a rising mist.
I climb as a
squirrel climbs
into a narrow crevice
wet with seeping water.

Suddenly I am
on a high bluff.

The rope is in my hand
but the canoe is gone
and the river's
rush is silent.
My mother who died
of smallpox
sits on a rock nearby
scratching a turtle
in the stone.

How did you get here,
I ask,
where's Father?
She points to the
turtle she draws.
Look for him
when the sun
warms the stones
at noon, after
the flood has
settled its bones.

I see nothing.
The crow calls
in the forest.
He has made me
like himself. The
lonely crow has
made me like him-

self. I am bound
to the rock
by the harsh
song of her scratching.

Fort Pitt

May 9, 1765

I. Lawaughqua

Here is your flesh and blood,
which we have pledged
by treaty. Though we give
them up to you, they
are our family. We
took them as children into
our homes. Now we
weep for them. Use
them kindly, for they
have forgotten your ways,
and some no longer
speak your language.
Though our hearts weep,
we will sweep their
places around the fire
with leafy limbs
so their presence can
no longer be seen.

II. Kyashuta

*You make rum and taught
us how to drink it. You
are fond of it yourselves;
therefore don't deprive us of it.*

Nimwha

You think yourselves masters of this country,
because you have taken it from the French,
who, you know, had no right to it,
as it is the property of us Indians.
 —to George Croghan, Fort Pitt, 1768

He nodded, but I knew
the glass he kept
hidden in his bag
had twisted his heart.
I knew the English
outdid the French.
They say they only
hunt and trade, but
I have seen Croghan
looking through
his glass when he
thought he was alone.
I saw it measure
and cut our land
like a shirt from
tanned deer hide.
He lived with us
at Eskippakithicki.
He knew Catahecassa,
the great Black Hoof, there.
They are deaf
when we complain.

When we kill
and burn them out
they are like
a hornet's nest.
There is no end
to the stinging
misery they bring.
Though it is
not yet so,
I know a river
of whites is a coming
flood that will
sweep us all away—
Shawnee, Mingo, and Ojibway.

Kyashuta to George Washington upon Meeting Him along the Ohio, 1770

Seventeen years ago
we went together as
warriors to warn the French
off the Ohio. Now, beside
the same water we meet again,
grown more into our lives.
Many have died since then.
Forests of untold years have
been cut and cast into the fire.
Buffalo are gone and game scarce.
I know the secrets of generations
on the Kanawha, but we
live in a smaller world,
and the coming war against
the British will shake off
our nations like a dog
its fleas.
Once we could have
shaken you, but wasted our-
selves against each other.
Now we must be practical,
or die. So—
Greetings old brother.
Let us sit and smoke and
remember our youth when we took
tomahawk and rifle against
the French along the beautiful river.

Beniwerica

1770

Though we thought
we made a peace
with men of honor,
their words didn't matter.
Land-starved whites
flowed in like water.
Bear and buffalo
killed and left to rot.
They took our land and
said we did not use it.
We only hunted
and did not plow.
I see now how it is,
first we're vilified,
then we move or die.

Our life here is
older than memory,
yet whole nations have
melted before the whites.
How quickly did they go,
the people and their buffalo.

Bonah

St. Asaph's, 1778

Hidden in the shade
we caught them
in their fields
away from safety
in their stockade.
I shot the man
in the field
through his head.
Big Owl shot
the other in the gut,
and he lay howling
on the ground
as Owl took
off his scalp.
Red Pole caught
the boy and with
one stroke ripped
away his hair.
I saw the woman
hiding in the weeds
and took her with
us as we ran.
Before dark we
walked a stream
to hide our trail.

At dusk we
stopped and made

a little fire.
We made her
cook with scalps
slowly drying
beside her.
She seems strong,
and will make a slave,
or wife.

The Prophet

I. 1795

How eagerly we took
the white man's bait.
In one lifetime we
began to forget ourselves.

Where are the buffalo and deer?
I see only tame cattle
that we must feed
and pigs that root in dirt.

Where are our bows of ash and
the hickory arrows they sent flying?
I see our guns and leaden shot,
but we can't make them.

Where are the deerskin clothes
and the good warm buffalo robes?
I see the white man's cloth,
but we can't make it.

Where is the good Indian corn
and the bread we make of it?
I see the white man's grain,
but we don't grow it.

Where are our villages
untouched by the rum

they gave to make
us drunk and foolish?

Manito made this land,
then made us for it.
The trail of the buffalo
is older than our people.

We took their rum,
their pigs and cattle
and their soft clothing.
Now look what we've become.

II. 1800

I dreamed we
were dazed by hunger,
walking in a meadow
full of empty bones.
Hunger lay in our
stomachs like stones.
The bones began to
come together with
a hard, rustling sound.
Skin and fat,
sinew and muscle
rose from the ground
and bound the bones
of slaughtered buffalo.
The people fell upon them
in their terrible need,

but their hands could
not hold them and
their teeth could
not tear through
the strong coarse hair.
Wheeling crows filled
the air with the noise
of angry disappointment.
Our children cried.

We are all sleeping now.
We must awaken and
remember who we are,
before we pass away
and are forgotten.

IV

Long Hunter
Kan-ta-ke, 1755–1756

. . . I have thought / Too long and darkly . . .
—Byron, *Childe Harold's Pilgrimage*

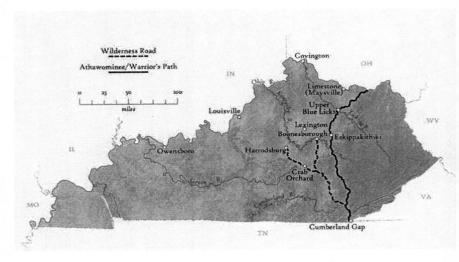

First paths into Kentucky. Map by Jeff Levy, Gyula Pauer Center for Cartography & GIS, University of Kentucky

Beyond the Mountains

Jack Gordon

My family dead
in a Clinch River raid,
Meg, boys, brother.
All killed. Neighbors too.
Shawnee threw bodies about
like a savage wind,
took scalps, then passed.

I could not save them.
With Ben and others, I
dogged their trail for two
days, then caught them camped
and unaware. We were an
even fiercer wind. I went
among them with my ax.

Then, with good Ben Hill
I sought the western mountains,
through the Gap, past
the Blue River of the Piqua,
past the Temasqui that the
Keetoowah loved, past even
the furthest survey of ourselves.

turrabel cainbrakes

In October we left the
Blue River and came upon
a green one flowing north.
About noon on the fifth
day we hit a great
canebrake stretching away
from the river beyond

our sight. Thinking it
long but narrow we
entered, took our axes,
and began to hack
our way. The weeds, some
twice our height, enclosed
us like a cage. By dusk

we'd seen no end
and slept off
the trail we'd cut
for fear we could be
followed. So we rose
each day and began again
to chop our way. For three

days we labored in this
thicket, our hands numb
with the shape of the haft
each night, our shoulders

and arms full of tired lead.
Though the nights were cool,
each day the cane heated

up like a drying oven
and we suffered an awful
thirst. The sun in a cloud-
less sky fell through
the leaves, and the terrible
cane rattled and clacked
as we cut and hacked.

Bear

We saw its track
so like a fat human
one with claws,
then came across
a dig where the ground
around a rotten log
was roughly torn for grubs.

What we missed were
the smaller prints of cubs.
She charged from the tangle
of a laurel thicket
and took us by surprise.
I shot from where I
sat and tried to rise,

but she came on too fast
and knocked me back
as I fumbled for my knife.
Ben stepped up boldly
to her side and fired a ball
into her ear. She fell
on top of me and died.

We rolled her off
and praised our luck
then began to skin away

the hide. Two weeks now
without our bread we
gorged on bear meat
boiled in its autumn fat.

Ambush

At the first shot we
scattered. I ran
down along the river.
A second shot and I
heard Ben yell,
Save yourself, Jack.
I'm done for.

I turned and shot
the Shawnee behind me,
and ran hard for
a stand of cane, reload-
ing as I went, then lay
in the rattling weeds
my rifle fully cocked.

Two hunted me awhile
and twice came close,
then gave it up
returning to their prize.
I lay hidden until
the only sound was
the softly swaying cane

with its long hollow sigh.
While I waited I
prayed that Ben had died.
Then I waited even

more until the cane grew
dark and a chorus of tree
toads sang unstartled.

I never saw Ben
again, but two weeks
later heard from three
friendly Miamees that the
Shawnee took him alive, shot
cleanly through the thigh.
He tried to shoot himself

but his pistol had misfired.
They crossed the Ohio hoping
to burn him slow, but full
of fat from the bear we'd
killed he burst at once
to flame while the Shawnee
whooped and roared in rage.

Alone

I.

Wild grapevines overrun this
place. They cling all around
to chestnut, oak and gum
binding them to the ground.
I cannot see past
the awful complication of
their tangled branches.

I've come too far. My
mind is full of the
whining tear of briars,
the silence of peopleless spaces.
Looking outward,
I see only wilderness
and the brutal drama of animals.

II.

The trees stand tall
and still until a wind
pushes through them
and sets them dancing.
Deer settle down
in their cedar houses.
A gang of crows gathers

to jeer and scream at
a hunting hawk. I too

hunker in my half-faced
hut. The rain speaks in
words of a million syllables.
Be still, it says,
there's no one here.

III.

I lie on my back
in a patch of new grass
the buffalo have not found,
though I counted more
than a thousand moving past
me to a lick in lower ground.
So many I thought there'd

never be an end. Now
the stars come out slowly,
then suddenly they're thick
as smoke from a huge
but distant fire. I stare
into them until I feel
myself rise, leaving

a fading body behind.
A party of Shawnee
pass silently eastward
on a raid. Hidden here
I see their painted faces
while I, invisible in the sky,
lie trembling in the grass.

Winter Dream

Troubled by dreams I wake
trembling in the cold, despite
my heavy buffalo robe.
The universe above me,
swollen with time,
is drifting slowly through
the bare arms of frozen trees.

The silence of the hard, clear
air is absolute. Even the
hunting owl is still.
Suddenly, I feel her embrace
me from behind. I rise
and turn, then step out
into speechless snow.

Fire

Huddled in this hollow tree
I make the best
of my frugal fire,
a small lodge of flames
and coals to keep the cold
away as winter air cracks
and breaks around me.

The tree's empty hull
is blackened by lightning
that lit it like a torch
and brought it burning down,
a ferocious flame that seems
impossible in this frozen forest
where I squat and hide.

The image of poor Ben Hill
huddled in his chains
as the Shawnee tried to roast
him has made me stingy
with fire even in this wild
wooden world lying
in a jumble and rising up

around me. I have seen
the hunters' tracks down
by the tangled cedar thicket

and seen the bear's blood
upon the frozen ground.
Fire beckons to fire.
I sit here, a miser of flames.

Wintering

If my heart were
still blazing as it was
that day we caught and
slaughtered them, it could
not warm my freezing
hands and feet. Even
wild hemp sighs

and breaks, oozing its quickly
freezing heart into little
blossoms of ice and frost.
I'd best retreat to my
hidden half-faced hut
and the warm buffalo robe
I traded from the Cherokee.

Though they tolerate me
now, I'll hold the robe
like a chimney around me
and my measly fire. I know
they're headed south before
the rivers rise. I'll hunker
here, and not advertise.

Falling Asleep while Hunting

Where hickory ends
cedar begins, a dark
house where deer stir
uneasy in the fragrant rooms.
I enter through the hall,
the one dry ravine
where an ancient tablet

of bedrock is revealed.
This is where the buck
hung back, letting
the does go first.
I lie on sun-warmed
stone. My gun is laid
aside. The smell of evergreen

and gentle Indian grass.
The leaves, the rock
the tick of the briars' dry
brown clock. The buck
motions, but I don't understand.
Then he stands and sheds
his soft brown skin.

Boustrophedon

Long-necked sycamores
grazing beside the creek
tell me of their lives along
the water while new grass
rises and repeats on a
brown page the same
winding message of the creek.

Absence

I come upon it
like an unexpected gift.
The grass has not
yet unbent itself,
the air still shaped
around the upraised
head and horns,

the buck himself already
beyond my eyes
and ears. Cedars rise
in a wall. I take
what's given, dark cedar,
blue day, the shape
of something gone away.

Owl

I watch the owl
glide in, silent as
leaf flush glowing
in the trees. He knows
the quick motives
of ground squirrels,
is intimate with field mice.

A crowd of clacking crows
follows, full of anger
and fear. They blow
around him like ashes
from a fire. Why do
they hate his loneliness?
I've come to cherish mine,

but the paths of deer
have deceived me with thicket
and briar. I strain to hear
the whine and tear of their
intricate message. My own
stormy crows rise up to jeer
my quietly brooding owl.

Footprints

Devil Creek

I.

Heat like a hammer hits
and a swarm of mosquitoes
has at me in a frenzy.
First the wretched black-
berry thicket, then through
an endless stand of cane
that traps and keeps the heat.

Now the cooling creek
where I soak my feet
in water sluicing thinly
over slick rock. There I see
them, footprints in red sand-
stone, some bare, others
moccasined. Left foot,

right foot, a man's
track, here a child.
A large bird stalks
them. Another left
foot with a long big toe,
the next two missing.
I touch the tracks,

amazed at feet
in solid rock before

Shawnee and Cherokee.
Who were they
who crossed here alone,
long enough ago for steps
in sand to turn to stone?

II.

The boy hurries to keep
up. The crippled one
slows down for him.
The great blue heron
comes later. Seashells
and gaudy feathers traded
south a month ago are now

a burden in the northward
journey home. Even the boy
must carry, and they must hurry.
The sun is going and they
need a fire against
the night. Long-toothed
cats will soon be hunting.

The serious heron crosses
behind them, nervous
at its own movement
in the falling light, and strikes
at one last fish in haste
then flies with a squawk
to its secret roosting place.

The Chain

Since I cannot see
the top of things,
I'll start where I am
with the squirrels I hunt,
here in this muggy bottom.
No. I must look down
to the lowest on the ground.

The cursed mosquito
in its gauzy gown
that whines around
my eyes and ears?
No. Lower yet. The invisible
chigger that infests the weeds
and loves the moist

warmth of my crotch
and makes my nights
a hell of sleepless scratching
despite the bear grease
plastered on. I wonder
the Shawnee out hunting bears
don't track me by the smell.

Is this the bottom
of the visible world
before the kingdom
of the grass? I do know

the lowest thing there,
am intimate with the catch
and tear of saw-toothed briars.

And easily name the top,
the oak with its great tower
raising its crown, a bower
two hundred could gather round.
No, the oak and briar
are the easy parts. It's harder
to parse the weeds between,

though I do admire
the ironweed with its
tall tough stem
and darkly purple flowers,
and the Indian tobacco
that some call bluebell
and the Shawnee use for fever.

When the squirrel finally
moves and shows itself,
I shoot and hear the
dead thump. Is this
the path up, the warm
body with a blowfly still
living beneath the skin?

With my knife I cut
out the thing in its side,

the awful larva that
must have been a torment
to the living squirrel.
Should I have started here,
with this squirming lump of fat?

Is this the squirrel's chigger?
Its itch the link
between it and me?
How did Adam and Eve
ever get to the end of it,
this ritual of names,
this placement on the chain?

Is there some itch
within this grub that
causes it to jerk
and twitch upon my hand?
Its chigger? And does
that chigger in turn have its own?
How deep does torment run?

Bread

Bloody hands again,
full of the doe's warm
gut. Sick to death
of meat I wash in the
cool waters of the creek,
but blood the color of rust
stains my nails and hands.

I dream now of bread
and wake with the smell
of Meg's kitchen in my head.
If we cannot live
by bread alone, how long
with none? Not rough pone
but wheat, finely ground by stone.

Weariness

Having gone as far
as I can go, I stop.
A year now since Meg
was killed. I pray
she never heard
the shot that blew
the ball into her head,

nor the boys felt
the Shawnee's cruel knives.
This year of wandering
is like an isinglass that
warps me to my parts.
The green river beside me
is rising from this week's rain,

but loneliness is its leaven.
The great sycamore's hollow
is a darkness, and leaf goes
on to leaf and makes a roof
that cuts me off from heaven.
Even the titmouse chatters
that the world is wearing down.

Question

I camp tonight
where others were
before me. From a
rise I see the vague
shape of a town
with marks of cabins
and still-dark firepits

scattered all around.
Further down beside
the creek the faint
image of a village garden,
most likely Indian
corn, squash, and beans.
Were these the fathers

of the Shawnee? In this
year of wandering I've
found no living towns.
What happened to the
people I feel silent
around me? What plague
raged and cut them down?

Big Bone Lick

I.

Following a buffalo road
I come to a big lick
where all the ground
is widely padded down
by great mumbling herds.
Here also the delicate
prints of careful deer

and there the broader
hooves of elk, one
at a gallop, dewclaws
extended. And circling
at the edge, the straight tracks
of hunting brush wolves,
the stalking pads of panthers.

But here also a mystery,
the great bones of elephants,
monstrous thighs and tusks
protruding from the mud,
and one huge skull, its
crown gleaming from the earth
like pale limestone.

Savages, too, have marked
the place with cuts and signs.

Some within this lifetime
were made by Shawnee
in old wounds on oaks
and beeches, but those
on rocks are older than

memory. A dull black
circle with forms I
cannot cipher, and the red
figure of a cat standing
like a man with human
hands upraised to threaten
or to tear and rend.

I feel the earth
and the rocks throbbing
with past life, the lick
teeming with milling herds
spooked by slowly moving
hunters, some on four
feet, some on two,

the dance always the same.
The hunter takes the prey
and they move on, then,
one day they're gone.
Now I wait in a locust
grove. Rifle ready, I look
to where they'll come.

II.

The hunters hide on the far side
of the mud. They wear skins
against the cold and hold
fluted harpoons cradled
on their throwing sticks.
One, dressed in the
skin of a long-toothed
cat, stalks slowly
from the other side.

The mammoths mill
about uneasily. Suddenly
the cat-man springs up
with a grating howl.
The big animals knock
against each other. Then
the rout begins. One
is slowed by the mud.
The hunters rise and throw.

V

Voices from the Great Migration
1750–1792

What a buzzel is amongst people about Kentucke.
To hear people speak of it one would think that
it was a new found Paradise.
> —Rev. Lewis Craig, Virginia, 1775

Dr. Thomas Walker

West of Cumberland Gap, 1750

In a sudden laurel thicket
the dogs stopped and lifted
their ears. The bear burst
out and took the closest
dog. We stood still and
shot from behind a rotten log.
We were very lean,
and the dogs howled
for the meat.

Mary Ingles

1755

They killed my children
and took me
in my late term,
in the heat of summer.

That night I cooked
while they dried my
children's hair, stretched
on green willow branches.

Three days out I
delivered. I thought
then we'd die, but
they put us on a horse.

I did what I had to do,
I continued.

Their leader looked so savage
I was filled with dread.
He had a nose ring
and feathers through his ears.

His face was painted black and red,
but in their town my baby thrived.
I did the work of other women
and Tecoma took me in his tent.

I did what I had to do,
I survived.

In the fall, among
the bones of giants,
we made salt while
the maples warned of winter.

One day while
the men were hunting
I left my baby
and slipped into the woods.

I used the creek
to leave no track,
then went along the river.
As I ran I cried.

I did what I had to do,
I did not die.

In Virginia, though
Bill embraces me,
I feel the others' looks
and wear the invisible

mark of taboo
for having slept with
savages. My second
children are all

around me, but I dream
still of my lost baby
and see the dead
ones in their faces.

Then the soft
persistent clothing
of loss settles
down upon me.

I did what I had to do,
I'm still alive.

The *feeling infinite*

Then stirs the feeling infinite, so felt
In solitude . . .
—Byron, *Childe Harold's Pilgrimage*

I. Daniel Boone, 1770

Squire five days gone,
I've waited here
happy in my solitude,
but keep a ready rifle.
Already there is color
in the leaves
and light flattens
across the land.
Pig hickories like
shaggy beasts are
ready to shed their fur,
while maples torch
the woods. Today
the sky a blue void
while I, laboring under
an ecstasy, lie on my
back in the warm grass
and explain myself
by singing.

II. Casper Mansker

After Sam Welch
was taken, we moved

through the woods
so lightly we all heard
the noise together.
I shifted my rifle
to both hands,
feeling its smooth
walnut arm, weighing
its long lean barrel.
Keep sharp, I said,
it's Indians.
The trees gave way
to prairie as we crept
up a little rise. We
waited below the crest
while Drake disappeared
in grass chest-high.
He returned grinning.
*Some damn fool's there
on his back a'singin.'*

Henry Lee

1774

Oscar Rhea,
hunting on Crow Creek
met some Indians
who knocked him down
with their tomahawks,
and scalped him.
Neither broke his skull
nor killed him.
His dog licked
his head
'til he recovered.

Down the Ohio: Indian Summer, 1778

Jeptha Kelly

No noise but the
water's flow. We
held the raft in
the river's channel
and never stopped
watching the shade.
Bright October days
brought Shawnee
across the river for
one last hunt or raid.

We heard, then saw,
two men pleading
for us to stop, but
afraid of who lay
hidden in the trees,
we went on. They began
to shout and curse.
Then we saw them,
two large canoes of
warriors. Their first shots

killed young Ebenezer
and wounded John Nokes.
We shot back and fought
to keep the raft
in the strongest current.

The first canoe
caught us as I
struggled to reload.
Ruth screamed and
tried to hide, but

Sarah grabbed an ax
and struck the first
man in the chest.
He fell back into
their boat and I
shot the next one
in the throat. Their
canoe rocked sharply
and went broadside
in the current,

blocking the other
boat. The water
hurried us along and
we passed around a
bend. Reloaded we waited,
but never saw them
again. In the mild
blue weather we watched
the shore and water, while
our raft went down the river.

Through the Gap

1778

I. Barbara Lewis

When we reached
the Gap, a mountain
rose up on our
right, 1000 feet
above us. The solid
sky lowered itself
like a lid and
hid the view below us.
Susie began to cry.
I tried to com-
fort her, but the
trail before us
was dark with trees
and dropped into
a thick, blank fog.
Suddenly the smothering clouds
began to run down
the hollows in silent
torrents, a beautiful
and terrible sight.
A wind came up
and blew the mist away.
We saw then,
for the first time,
the new, green land

and entered the
narrow, winding trail.

II. Susan Lewis

We passed
Blackamore's Station
in Powell Valley.
It was early spring

and the flowers
that Father calls Indian
tobacco, though
I say bluebell,

were scattered about
like little violet lights
in the cool green grass.
I would have

stopped here freely
but could not,
for Father was
bent for Kentucke.

He'd been
out here be-
fore he married.
So we left our

wagon at the Gap
and went on, past
the bones of dead
horses. Babies and chickens

bobbing from saddle
baskets. That first
Spring out, the
men stood sentry

while we milked,
and the land
came on sooner
than I'd ever seen.

In the winter
we were crowded.

Ella Mulligan

I. 1779

After Christmas
we began to live
without bread,
saving seed corn

for the spring.
I tried to fashion
flour from ground
hickory nuts, but

it hardly baked
and the children
were not fooled.
So we planted

in the spring and
prayed and nursed
the little shoots
until a fine field

stood in the bottom
by the creek.
In the eighth month
of our trial

the corn raised
its arms in the

August heat and
showed green husks

filling with a promise
too dear to name.
Then a sudden northwest
weather brought hail

and early frost.
Two days we worked
but everything was lost.
I could not think

of winter without dread,
boiling meat each night
while the children
cried for bread.

II. 1780

The Shawnee come
like phantoms.
They come like foxes
through the woods.

They attack, then disappear,
turkeys flushed
but running. Gone
before we see them.

We live so far
from neighbors
it was two days
before we found

the Stantons slaughtered,
their station burned,
little Sarah gone
into a savage nation.

Mary Hite

1780

The stockade is a horror
standing around me.
I cannot look upon
its hacked-up timbers.

My boy's murder
burns like the
forge's furnace through
these wooden walls.

The lifted knife,
his cries to me
that will not die,
hair and bone ripped off,

the savage's hideous
cry flung against
these logs. There was
no help for it.

I sat there
on a stump
outside the fort
and wept all day.

John and my sister
speak to me, but

I'm not here.
I'll stay far away

where there is no
howling wilderness,
no cruel murder
in our plowed fields.

No matter what
they say or how
they cry, I will not
wake and let him die.

On Dick's River

William Survant, 1782

Hunting near the river,
we thought it was
a rising wind
coming through the trees.

As the sound grew closer
we saw trees and ground
alive with squirrels.
Thousands flowed down

to the river and swam
for the northern side.
We grabbed sticks
to save our shot,

then waded among
them with our clubs.
We stopped when
our arms were weary

and the dead and dying
lay piled around.
We gathered them
in sacks for stews

then hurried back
to the hungry station
for a week of
feasting on burgoo.

Uriah Boyd

1784

After the raid
that killed my son
and left poor Levi
sorely wounded,

we began to
track them down
and caught them
resting on a log.

I wounded the one
wearing my Isaac's
hunting shirt, then
killed him with my ax.

In my rage
I chopped at him,
then fed him to our
always hungry dogs.

Sometimes it seems
my Isaac comes
in terrible dreams
to shame me.

Clinch River Ford

Jane Trimble, October 1784

Pressed by those
behind, my horse
plunged into the water
but missed the ford and
struggled in the current.
I held the baby
and my son in front
and grabbed the
the mane to let him

find the ford
and we came on
across the river.
Ida Irvin behind
me, with two
Negro children
in a wallet across
her saddle, was pushed
to deeper water, and

her horse swam from
beneath her. She
struggled to the ford
but the wallet with
the children floated
down the river until
Charlie Wilson saw

a chance and pulled
them safe to shore.

In this manner
we began our
journey to Kentucke.

Defeated Camp

James Trimble, 1784

News had spread
of the massacre,
but we weren't
prepared for the
fifteen bodies scattered
about the camp
tomahawked and scalped.
Only bones, sinews
and bloody bits
of clothes remained,
it was plain
wolves and vultures
had been at them
for a while.
As we approached
we had to
drive them off.
It was late when
we dug the graves
and reluctantly
spent the night.
The next morning
a huge bear charged
furiously into camp.

We shot him
and took his skin

but left the meat
though it would
have filled our larder.
We would hardly
eat of an animal
fattened on human flesh.

Ada Milbank

1785

I was forted
since I was seven
in 1770 and never
rid of Indians
'til I was grown.

First summer out
Indians raided Stephen's
Station and shot
all the cows
with their arrows.

Mother was killed
when I was eleven.

First Frost

Cassandra Magruder, 1788

Frost matches the exact shape
of shade. The first hard freeze
has touched the tough weeds
that hang about our cabin, greedy

for the light and space opened
by the deaths of tall trees
Arch felled for the cabin.
Asters have wilted under its weight

and sunflowers are covered with soft
white hairs. I move the churn
to follow the sun as it eats away
the frost and shade. Butter forms

and I ladle out what
I have made, the milk
sweetened by pumpkins our
cow has fattened on. We enter our

first fall here. This early frost
warns of winter while Zeke
and Nellie bob beside the cabin
like sea birds on a rising sea.

The cabin with its gun slit
like the porthole of a ship
raises its western side to breach
waves of trees, swells of gathering cold.

Autumn Snakes

Archibald Magruder, 1788

I kick them up
from autumn's layered leaves.
Each mimics his space
so slowly, I cannot see
what I see, three

small, brown snakes
with scarlet bellies, sluggish
on the ground. Carefully I
lay them in the sun.
A glance away and I

strain to see them
in the leaves. Three minutes
and they're gone. I turn
up leaf mold to prove
the snakes again.

Only a grub blinks there,
blinder than a bone.

Gathering Browse in Winter

Archibald Magruder, 1789

Hay gone, I go
to the woods to gather
browse, small limbs
with leaves entombed
in buds for our mild cow.

Slippery elm is best
with its gummy fragrant juice
that Cassie sometimes boils
for croup and cold congestion.
White elm and pig nut

will also do. The woods
are quiet with cold. I
break brittle limbs, startling
up crows that pull
and tug at the carcass

of a rabbit frozen tightly
to the ground. Cold is an
inertia that binds the
rabbit to earth, which
I must break by moving.

I smell elm on my arms,
its odor rich in the dry air.

My vegetable self, imprisoned
like its leaves, pushes numbly
against my body's bud.

The *hard winter*

Cassandra Magruder, 1789

The cold came early
and never went.
The ground and sky
filled up with it.

The river froze
too thick to break
and each night rang
like solid bronze.

Turkeys froze
and fell from their roosts.
Deer died in their beds.
Buffalo starved in the fields.

We used our axes on the pond.
We filled the floor
with Indian grass.
We fed the fire with logs.

We ate our cow.
We ate our dogs
and boiled their hides.
Then, one of the children died.

Mingo Bottom

Archibald Magruder, 1792

When we came
into the country
in '88, the
buffalo were gone.
I never saw one alive.
Slaughtered for their
hides, only a little
meat was taken,
some hump,
a thigh bone
for the marrow.

Their roads at
Blue Lick were
forty yards wide,
and the Indians
who hunted them
lived in Mingo Bottom,
prairie then, cornland
now. But for
bones and names,
this would al-
ready be forgotten.

VI

A Codicil

In this region mixed deciduous forest continued uninterrupted
for millions of years, although elsewhere it was killed off. . . . In
the Cumberland Mountain section of southeastern Kentucky it
attained its grandest development . . . one of the finest deciduous
forest areas of North America.
> —*Trees & Shrubs of Kentucky,* Wharton & Barbour

My Lord, he said unto me,
Do you like my garden so fair?
You may live in this garden if you keep the grasses green
And I'll return in the cool of the day.
> —"Now is the Cool of the Day," Jean Ritchie

Coal

The shallow seas
rose and fell quietly.
Great swamps lived and
died along their rims.
There were no seasons.
There was no end to
the warm moist weather.
Life had no limits
in oxygen-rich air.
Plants exceeded
the imagination.
Mosses grew
to forty feet. Ferns
and horse-tails
to sixty. Slender
climbing plants with
whorls of leaves
threatened to over-
run them all.
The seas shimmered
with small animals
devoured by five-armed
hunters and snakelike
worms. Giant mollusks
with toothed hinges
were disembodied mouths.
Great sponges and
tree-sized corals

filled up the floor.
Armored fish with
the jaws of snapping
turtles ambushed tiny
plant-eating sharks.
Lungfish and fifty-inch sea
scorpions invaded the land.
Dragonflies with thirty-inch
wings filled the air.
Giant spiders and
oversized ticks
roamed the forests
flashing like exotic
jewelry. Here,
diamond-encrusted
gold brooches
stalked the undergrowth
for anything smaller
than themselves,
there, emerald and
ruby earrings clung
patiently to drooping
fronds, waiting
for a meal.
Twenty-foot lizards
with scales like
plates hurried by,
quicker than dinosaurs.
Seven-foot millipedes
were voracious.

The swamps and seas
came and went.
The vociferous struggle
of all the ravenous
creatures, the intricate
motives of the great
plants were forgotten
under the unbearable
weight of three hundred
million years.
Reduced to their
lowest selves, they
became buried seams
of voiceless coal.
They waited in
smothered darkness
for coughing diesels
to move the earth,
releasing once more
their urgent hungers,
the burden of their
needy appetites
into the hills
where waw-bi-
gon-ag, wild-
flowers Shawnee
girls once loved
to wear, would
wither and die,
where lilies would

no longer chase
the dripline of
retreating snows,
old ones falling
as new ones rose.

Acknowledgments

The author wishes to express gratitude to the publishers of the journals in which the following poems, sometimes in earlier forms, first appeared:

Adena: "The Turtle Clan" (revised from "Turtle")
Bryant Literary Review: "Owl"
Louisville Review: "Autumn Snakes," "Coal" (under the title "Coal: A History"), "Falling Asleep while Hunting," "First Frost," "The *hard winter*" (under the title "Winter")
Open 24 Hours: "The Prophet" (under the title "The Complaint"), "Winter Among the Mystassins"
Zone 3: "Boustrophedon"

I found valuable primary material, so far as there was a record to read, in the seventeenth century reports of the French Jesuit missionaries, *Jesuit Relations,* in pieces of the vast collection of writings known as *The Draper Manuscripts,* and in the journals of George Croghan, Dr. Thomas Walker, Christopher Gist and the autobiography of Allen Trimble.

I give my thanks to my friends Lamar Herrin and Jane Gentry for taking the time to read and comment on the early manuscript of this book, and to the staff of Western Kentucky University's Kentucky Library for their help in locating hard-to-find sources.

Index of First Lines

The Hiroquois barely tolerate me, 25
The shallow seas, 125
The stockade is a horror, 106
They killed my children, 92
Though we sailed in May, 15
Though we thought, 52
Troubled by dreams I wake, 70
Turtle, 7

We saw its track, 64
When I saw them wearing cloth, 18
When we came, 122
When we reached, 100
Where hickory ends, 74
Where they lived, 3
Wild grapevines overrun this, 68

Kentucky Voices

At The Breakers: A Novel
Mary Ann Taylor-Hall

Come and Go, Molly Snow: A Novel
Mary Ann Taylor-Hall

Nothing Like an Ocean: Stories
Jim Tomlinson

Buffalo Dance: The Journey of York
Frank X Walker

When Winter Come: The Ascension of York
Frank X Walker

The Cave
Robert Penn Warren

CPSIA information can be obtained
at www.ICGtesting.com
Printed in the USA
FFOW05n0343120314